British Museum Objects

CW00919615

The Oxus Treasure
John Curtis

THE BRITISH MUSEUM PRESS

First published in 2012 by
The British Museum Press
A division of the British Museum
Company Ltd
38 Russell Square
London WC1B 3QQ

britishmuseum.org

A catalogue record for this book is
available from the British Library

ISBN 978-0-7141-5079-6

Designed by Bobby Birchall,
Bobby and Co.
Typeset in MillerText and
Berthold Akzidenz Grotesk
Printed in Spain by GraphyCems

Papers used by the British Museum
Press are recyclable products made
from wood grown in well-managed
forests and other controlled
sources. The manufacturing processes
conform to the environmental
regulations of the country of origin.

The majority of objects illustrated in
this book are from the collection of
the British Museum and are © The
Trustees of the British Museum. The
British Museum registration numbers
for these objects are listed on p. 64. You
can find out more about objects in all
areas of the British Museum's collection
online at britishmuseum.org/research/
search_the_collection_database.aspx

Author's acknowledgements
Thanks are due to the British
Museum's Department of Photography
and Imaging and Axelle Russo-Heath
at the British Museum Press for
providing the images. Thanks also
go to Emma Poulter and Charlotte
Cade at the British Museum Press for
editing and seeing this book into print.

Contents

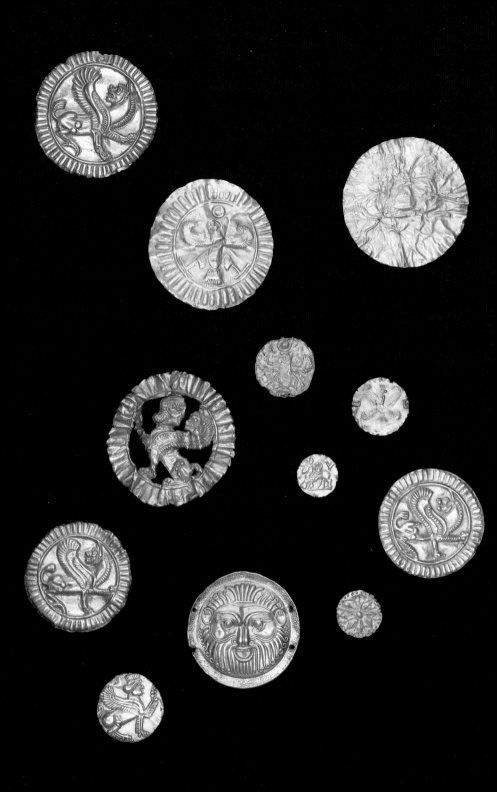

Introduction

1 Selection of gold plaques from the Oxus Treasure, probably clothing ornaments (bracteates), with various embossed designs. Some have loops at the back for attachment, and some are pierced so they can be sewn on to clothing. 5th–4th century BC. Diameters vary: 1.6 cm–5 cm.

The Oxus Treasure is an extraordinary collection of about 180 gold and silver objects and a large number of coins that is believed to have been found by local inhabitants near the River Oxus in Central Asia, in around 1877–80 at Takht-i Kuwad. Most of the objects date from between the sixth and fourth century BC, when a vast area of the Middle East stretching from the Aral Sea to North Africa was dominated by the Achaemenid Persian Empire, with its centre of power in modern Iran.

Taking its name from its legendary founder Achaemenes, the Achaemenid period is usually reckoned to start in 550 BC when Cyrus the Great, the Persian king of Anshan, deposed the Median king Astyages, and thereby effectively united the Medes and the Persians. Both were tribes speaking closely related Indo-European languages who had migrated on to the Iranian plateau from areas further north. In this book, the terms 'Achaemenid' and 'Persian' are interchangeable when referring to the empire.

By the ninth century BC the Medes were well established in the area around Hamadan in western Iran, while the Persians were later concentrated in the area now known as Fars in south-western Iran. In the centuries before 550 BC the Medes had been a powerful force in the Ancient Near East, helping to overthrow the Assyrian Empire in 612 BC, but they seem to have lacked a strong centralized government. After he came to power, Cyrus first defeated Croesus, King of Lydia (560–547 BC), making him master of much of western Turkey, then in 539 BC he captured Babylon, thus bringing under his control the former Babylonian Empire extending as far as the Mediterranean coast. Egypt was annexed by Cyrus' successor Cambyses II (530–522 BC) and the empire reached its greatest extent under Darius the Great (522–486 BC), extending from Libya in the west to the River Indus in the east, and from the Aral Sea to the Arabian peninsula (see fig. 2). This was by far the largest empire the world had seen up until that time. Much of Central Asia, including the area where the Oxus Treasure is thought to have been found, was

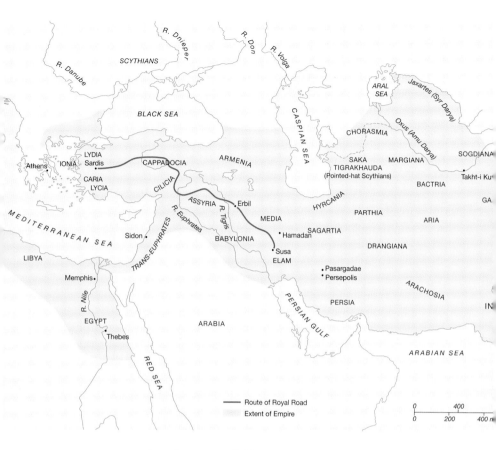

2 Map of the Persian Empire at its greatest extent (during the reign of Darius the Great, 522–486 BC) showing the main provinces, the route of the Royal Road from Susa to Sardis and the River Oxus.

therefore part of this vast empire. It was also in the reign of Darius that the ill-fated war with Greece began, which ended in a stalemate in the reign of Xerxes (486–465 BC) after a series of Persian defeats.

The main Persian centres were at Pasargadae, Susa, Persepolis and Hamadan, all now in Iran, and at Babylon, now in Iraq, but it is Persepolis – the ceremonial capital of the empire – that has captured the imagination of generations of travellers and is still today one of the best preserved and most evocative sites in the whole of the ancient world.

When Darius became king, he founded Persepolis as a new royal centre and ordered the construction of the famous Apadana (Audience Palace), a monumental

6

3 Part of the stone relief decoration on the north side of the Apadana at Persepolis showing delegations from around the Persian Empire bringing presents to the king. Each delegation is introduced by a figure wearing either Persian-style costume or Median-style costume. These styles are discussed on pp. 23–4.

building on the west side of the city. Of particular interest and importance are the carved stone reliefs on the outside of the Apadana. The significance of these reliefs, in relation to Persian art and material culture and to the Oxus Treasure specifically is discussed on pp. 52–57.

The Treasure includes some of the finest objects yet known from the Achaemenid period (550–331 BC), and is justly celebrated as one of the most splendid collections of gold- and silverwork from the ancient world. It also helps us to understand more about the character of the Persian Empire and the diverse influences that can be identified in the art of this period. On top of this, the recovery of the Treasure is a story of derring-do that is almost unrivalled in the sober world of archaeology.

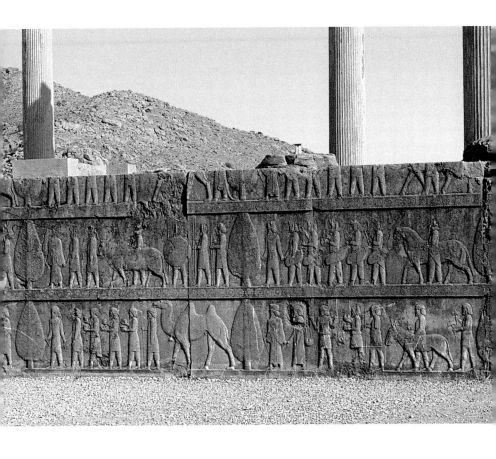

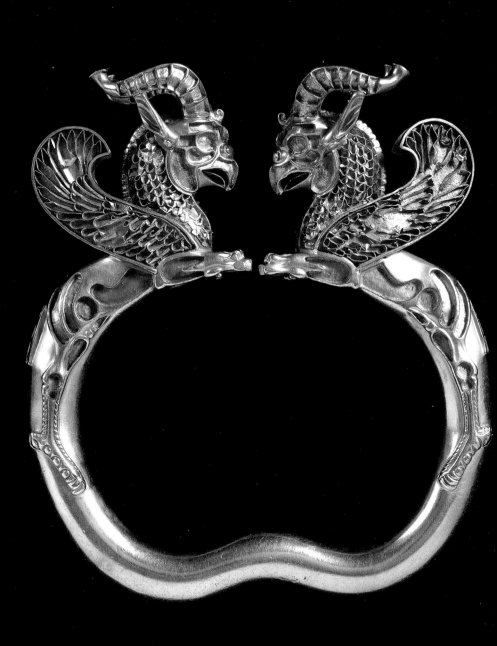

The discovery

There has been a good deal of speculation and confusion about exactly where, when and how the Oxus Treasure was found, so let us look first at what contemporary sources actually tell us about the discovery.

In 1880 the Russian Major-General N.A. Mayev, who was in charge of an enquiry into the management of the Central Asian railway, described in a Russian newspaper article how in the previous year while waiting for boats to cross the River Oxus, his mission inspected the ruins at a place called Takht-i Kuwad (in present-day Tajikistan), an important fortress on the north bank of the River Oxus. With the help of local workmen, they carried out one day of excavations. He wrote:

> Right at the confluence of the Vakhsh and Pyandzh rivers are the ancient ruins of Takht-i Kuwad. Local inhabitants who accompanied us stated that ancient objects had been found there and that they had even found in the rubbish mounds a solid gold tiger and other gold objects. They were all sold to Indian merchants for a high price. The diggers at Takht-i Kuwad were principally Turkoman [who live] on the Vakhsh.

This report suggests a fairly precise location for the discovery of the Treasure, and most other contemporary accounts are broadly in agreement with this. One of the earliest accounts is by the numismatist Percy Gardner writing in the *Numismatic Chronicle* for 1879:

> A few months ago as Mr Alexander Grant, Director of Indian State Railways, informs us there was discovered in [the Emirate of] Bokhara a large hoard of gold and silver coins [which are thought to have been part of the Oxus Treasure]. The spot is indicated by Mr Grant as 'eight marches beyond the Oxus, at an old fort, on the tongue of land formed by two joining rivers.' Now Takht-i Kuwad is certainly not 'eight marches [eight

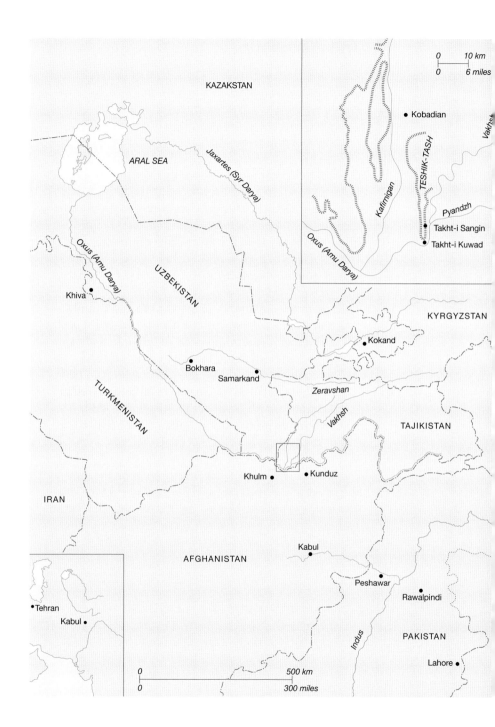

KAZAKSTAN

ARAL SEA

Jaxartes (Syr Darya)

0 10 km
0 6 miles

• Kobadian

Kafirnigan

TESHIK-TASH

Vakhsh

Pyandzh

• Takht-i Sangin

Oxus (Amu Darya)

• Takht-i Kuwad

Oxus (Amu Darya)

Khiva •

UZBEKISTAN

KYRGYZSTAN

• Kokand

Bokhara •

Samarkand •

Zeravshan

TURKMENISTAN

Vakhsh

TAJIKISTAN

Khulm •

• Kunduz

IRAN

Kabul •

AFGHANISTAN

Peshawar

Rawalpindi •

• Tehran

Kabul •

Indus

PAKISTAN

Lahore •

0
0

500 km
300 miles

5 Map of Central Asia showing the probable find-spot of the Oxus Treasure on the north bank of the River Oxus.

days march] beyond the Oxus' but it is on a 'tongue of land formed by two joining rivers'.

Further, in a later article in the *Numismatic Chronicle* (1881), Gardner states: 'Mr Grant is of opinion that all these coins are derived from the find by the Oxus River, of which reference has already been made in the Chronicle.'

Particularly informative are three different articles in the *Journal of the Asiatic Society of Bengal* between 1881 and 1883 by Sir Alexander Cunningham (1814–93), Director-General of the Archaeological Survey of India (1861–85), who himself acquired some items from the Treasure. In his first account, Cunningham wrote:

> In the year 1877, on the north bank of the Oxus, near the town of Takht-i-Kuwat, opposite Khulm and two days' journey from Kunduz, there was found a large treasure of gold and silver figurines, ornaments and coins, most of which have been brought to India for sale . . . It is perhaps rather bold to speculate as to how this large treasure came to be hidden. It was not all found in one spot; but scattered about in the sands of the river. One may therefore conjecture that it may have been concealed in the bank either in wooden boxes, or in vessels of earthenware, which fell to pieces when the swollen stream cut away the bank and scattered their contents over the sands.

Two years later Cunningham was able to provide more information:

> Since I wrote my previous account . . . several new objects have been discovered, as well as a large number of coins. The find-spot of these relics is on the banks of the Oxus, near a place called Kawat or Kuad, two marches [two days march] from Kunduz and about midway between Khulm and Kobadian. The place is one of the most frequented ferries on the Oxus, and has always been the chief thoroughfare on the road to Samarkand.

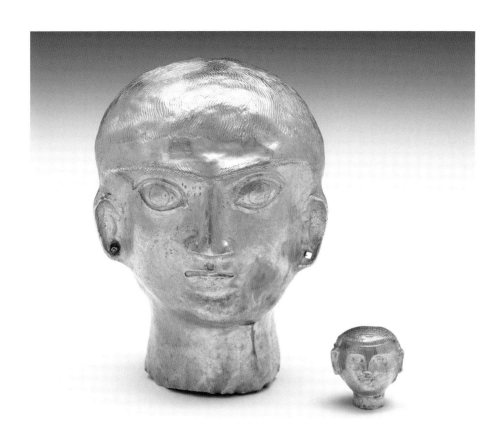

6 Two hollow gold heads from the Oxus Treasure, possibly from composite statuettes made from different materials. The larger head shows a beardless youth with short wavy hair and pierced ears. 5th–4th century BC. Heights 11.3 cm and 2.5 cm.

In Cunningham's third and last account some confusion about the location is introduced when he writes:

> After the above had gone to press, I met a man at Simla who has several times visited the spot where these Oxus relics were found. The place is one stage to the north of the Oxus, and is called Kawadian (Kobadian), a large ancient town on the high road to Samarkand.

This misunderstanding, placing the find some 50 kilometres to the north of the river, probably arose either because of the similarity between the names of Takht-i Kuwad and Kawadian, or because Takht-i Kuwad was actually in the administrative district (*beglik*) of Kobadian.

It seems more likely that the Treasure was indeed found on the banks of the Oxus, in line with Cunningham's earlier accounts.

This view was supported by Sir Augustus Wollaston Franks (1826–97), Keeper of British and Medieval Antiquities at the British Museum. He described the provenance of two objects from the Oxus Treasure that he had recently acquired (a gold finger-ring and a massive gold armlet) respectively as 'stated to have been found in [the Emirate of] Bokhara, in the bed of the Oxus', and 'believed to have been found with a hoard of gold objects in Central Asia on the banks of the River Oxus'.

Commenting in *The Graphic* of 26 November 1881 on one of the massive gold armlets in the Treasure (fig. 24, right), George Birdwood of the South Kensington Museum (now the Victoria and Albert Museum) also wrote that 'it was reported by the merchants who brought it from [the Emirate of] Bokhara, to have been found on the banks of the Oxus, together with a number of solid gold idols.' When the same armlet was offered for sale to the South Kensington Museum in 1884 it was recorded as having been 'found on the banks of the Oxus during the Afghan campaign of 1879–80'.

We also know that some elements of the Treasure were uncovered at different times. In 1889, General George G. Pearse (1827–1905) offered for sale to the South Kensington Museum (for £1,000) some eight objects and ten coins apparently from the Oxus Treasure. He stated that they belonged with the 'Great Trouvaille of the River Oxus' and had been discovered in 1876 when 'a land slip of the river bank took place and disclosed quantities of the old treasure.' Pearse's offer was not accepted, and in 1908 his widow sold the objects to the Calcutta Museum in India.

In the same year, a Russian officer, N. I. Pokotillo, wrote of Takht-i Kuwad: 'Despite the isolation of the site, there are always some tens of people there in search of treasure. They say someone once found a gold idol the height of a man'. (Though intriguing, this supposed piece has never been identified.)

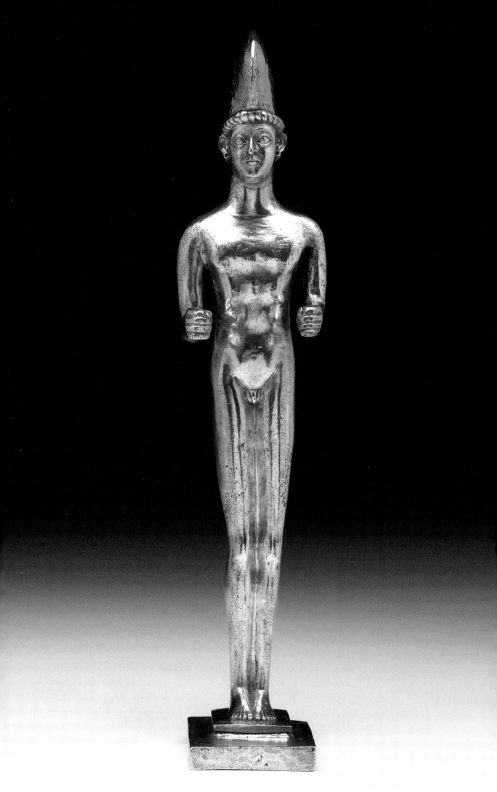

7 Silver statuette of a male figure from the Oxus Treasure that is naked apart from a tall hat which is covered with gold foil. There are vertical holes in the clenched fists showing that the figure originally held something in each hand. 5th–4th century BC. Height 29.2 cm.

In the 1905 publication of the Oxus Treasure, one of the merchants who originally purchased it is quoted as saying:

Most of the things were found at Khandian [Kabadian], which is submerged in the Oxus; but at certain times in the year when the river is dry, the people dig, and among the old ruins of the city of Khandian find valuable gold things.

We also have the slightly later testimonies of Russian scholars who also support Takht-i Kuwad as the find-spot. In 1909, D. N. Logofet described it as a site with ancient stone fortifications and referred to much gold having been found there and extensive illegal excavations. And in 1925, A. A. Semenov wrote, presumably referring to the Oxus Treasure: 'In 1917 the former Beg of Kobadian, Mirza Mahdibay, told me of remarkable finds [in ruins near Kobadian], in a mound half washed away by the waters of the river, consisting of metal objects which, judging from their description, were Achaemenid'.

From these accounts it seems clear that the Oxus Treasure was found probably over a period of several years (from 1876 or 1877 to 1880) and not all in exactly the same spot, but at a place known as Takht-i Kuwad on the north bank of the River Oxus, in what is now Tajikistan. Technically therefore it should not be called a hoard, as it may not all have been stored in the same place, and is better described as a treasure.

The theft and recovery of the Treasure

What was probably the largest part of the Treasure underwent a dramatic adventure. This is described by Ormonde Maddock Dalton (1866–1945), who wrote the definitive catalogue of the Oxus Treasure in 1905. Dalton was one of the most capable and versatile scholars ever to have worked in the British Museum, and as well as his work on the Oxus Treasure, he wrote with distinction about early Christian and Byzantine art and

archaeology, and many other subjects. According to Dalton, the Treasure was bought from local villagers by three merchants from Bokhara, named Wazi ad-Din, Ghulam Muhammad, and Shuker Ali, who regularly traded between Central Asia and India. In May 1880, they had with them a large sum of money to buy tea, silk and other goods in India, but after hearing that Abdur Rahman Khan (Emir of Afghanistan 1880–1901) was in Kunduz (south of the Oxus, now in northern Afghanistan) exacting a toll from all travellers to raise money for his army, they decided it would be wise to convert their cash into some other kind of currency before they crossed the River Oxus. As they passed Kobadian (now in Tajikistan, about 35 kilometres north of the River Oxus) they learned of the treasure for sale, which, once sewn into leather bags, could hopefully be regarded as merchandise. The merchants bought it and duly crossed the River Oxus, but were held up by bandits after they had left Kabul. We now take up the story in Dalton's own words:

> [The] three Mohammedan merchants from Bokhara, who were known to have a quantity of gold upon their mules, were robbed on their journey from Kabul to Peshawar by men of the Khurd Kabul [Barbakkar Khels and Hisarak Ghilzais] at a spot between Seh Baba and Jagdalak: they had foolishly gone on ahead of the convoy escort, and were thus themselves partially to blame for their misfortune. The robbers made off to the hills with the booty, carrying with them the three merchants and their attendant; they crossed the Tesinka Kotal and pushed on to a place named Karkachcha, where there were a number of caves in which they hoped to divide the spoil at leisure. Unfortunately for them, they allowed the merchants' servant to escape; and this man, arriving in Captain Burton's camp at nine o'clock at night gave immediate information of the robbery.

This Captain Francis C. Burton (1845–1931) was a British political officer based at Seh Baba, three marches [three days march] east of Kabul. His job was to keep open the

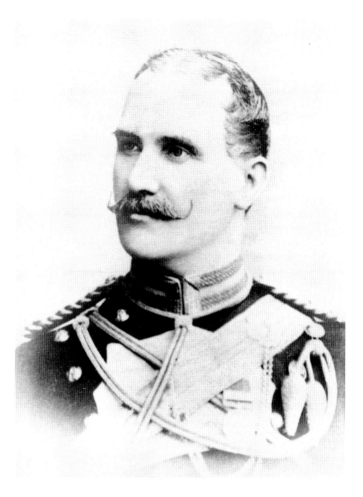

8 Captain Francis Charles Burton (1845–1931).

lines of communication between Kabul and British India in the aftermath of the Second Afghan War (1878–1880), during which he had captained a Punjab battalion.

Captain Burton at once set out for Karkachcha with two orderlies, and towards midnight made an unexpected appearance among the bandits, who had already been quarrelling over their plunder. Four of them were lying wounded on the ground, and the treasure, which for the purpose of transport in saddle-bags had been sewn up in a number of small leather packets, was spread out

17

over the floor of the cave. A parley ensued, as a result of which a considerable part of the spoil was surrendered, and Captain Burton then prepared to return without further delay, which might have been dangerous. A warning having, however, been conveyed to him that a plan was on foot to waylay him and recover the part of the treasure in his possession, he remained in hiding all night, and only reached his camp at six o'clock on the following morning. He at once threatened to lead a force against the robbers; but when they heard of his intention they came in with another large part of the treasure, bringing the total amount recovered up to about three-quarters of the whole; the rest was probably by this time melted down or concealed in some inaccessible place. The property was then returned to the three merchants . . . [who then] continued their journey to Peshawar without further adventure.

Unfortunately, the source of all Dalton's information is now lost, which has led some scholars to dismiss his account as fanciful, but it is to some extent corroborated by contemporary documents which have recently come to light. The most important of these is a detailed account in the *Lahore Civil and Military Gazette* for 24 June 1880, which reported as follows:

The *Civil and Military Gazette* has received the following particulars of the extensive gold robbery between Sei Baba and Jugdulluk, which was announced by telegraph the other day. A party of Khokandis had reached Cabul en route for India, bringing with them specie in gold to the amount of Rs. [Indian Rupees] 50,000 or 60,000, the property of Bokhara merchants. The eventual destination of the party was Constantinople, where it is believed they hoped to meet Kondiyar Khan, their late leader. During their stay in Cabul, the Khokandis made no secret of their possessing this large amount of gold, and it was there that the robbery was planned. The first intention of the thieves was to ease the owners of their burden between Butkhak

and Luttabund on the 10th instant, but, prevented by the presence of a large escort with the convoy with which the Khokandis were travelling, they decided to lay hands on the treasure the next day near Jugdulluk. For this purpose some 180 men collected, lying concealed among the low brushwood on the roadside until the convoy approached, when they dashed in between the up-country and down-country convoy, which happened to be close together at the time, seized the particular mule carrying the gold, which was at once driven off, and set free the rest of the animals to aid in the general confusion. News of the robbery reached Sei Baba by four o'clock, when Captain Burton, Political Officer, at once set men on the trail; his knowledge of that part of the country enabling him to make a shrewd guess at the whereabouts of the robbers. He also took early steps to arrest the Kafil abashi at Butkhak, whose complicity he suspected. It was at first intended to surround the village to which Captain Burton believed the thieves belonged; but on second thoughts, he set to work through some of his officials, and with the aid of Sardar Nasrat Jang, formerly a native officer in the Bengal Cavalry, succeeded, after some difficulty, in securing Rs. 21,000 in gold, and hopes are entertained that still more will be recovered. The very greatest credit is due to Captain Burton for the successful way in which he has managed this case.

This incident is also recorded in Burton's official record of army service, where it is stated that Francis Charles Burton of the 2nd Bengal Lancers 'recovered the looted treasure taken from the kafila [caravan] of Central Asian and Samarkand merchants amounting to over Rs. 60,000.'

During this incident, some of the items in the Treasure were damaged. According to Dalton, when Captain Burton caught up with the robbers in the cave, they were in the process of dividing up their spoil, which sometimes involved cutting up individual pieces. This was presumably because the robbers were only interested in the bullion value of the items and not their resale value as works of

9 Gold scabbard cover for a short sword (*akinakes*) from the Oxus Treasure with embossed decoration showing the various stages of a royal lion hunt. 6th–4th century BC. Length 27.6 cm. For a drawing of this scabbard, see fig. 21.

art. Thus a splendid gold scabbard (fig. 9) was cut into small pieces, some of which are still missing. Also, with a number of the torcs (neck-rings) and bracelets, the animal-headed terminals (end-pieces) have been cut off the original hoops and are now mounted on modern hoops of silver, which is of course a less valuable material. Whether this mutilation occurred at this time or later, however, it is impossible to say.

How much of the original Treasure was actually purchased by the merchants and was being transported is unclear. According to a statement that is supposed to have been made by the merchant Wazi ad-Din, the mule-bags that were stolen 'contained gold and silver ornaments, some cups of gold, a silver idol and a gold one, [and] also a large ornament resembling an anklet'. Wazi ad-Din continued:

> The whole value of the treasure was 80,000 rupees, and by your [i.e. Burton's] influence we have regained fifty-two thousand. The value of the recovered treasure was actually estimated at about 60,000 Indian rupees in the newspaper account and in Burton's service record, so Dalton was right to assume Burton recovered about three-quarters of the Treasure. He suggests that the rest was melted down or hidden. At the time there were about ten Indian rupees to one British pound, so the total value of the Treasure would have been approximately £8,000. This would be well over £1million in today's prices, but it is important to remember that the merchants were probably valuing the objects as gold bullion and not as art objects, in which case they would be worth very much more.

How the Treasure came to be at the British Museum
According to Dalton, after Burton had retrieved the Treasure from the bandits and it was being handed back to the merchants, he saw in one of the bags where it had been slit open one of the two splendid and now iconic gold armlets with griffin terminals that are such a distinctive part of the Treasure (figs 4 and 24). We are told that Burton offered to buy it, and his offer was accepted. In 1884 Burton

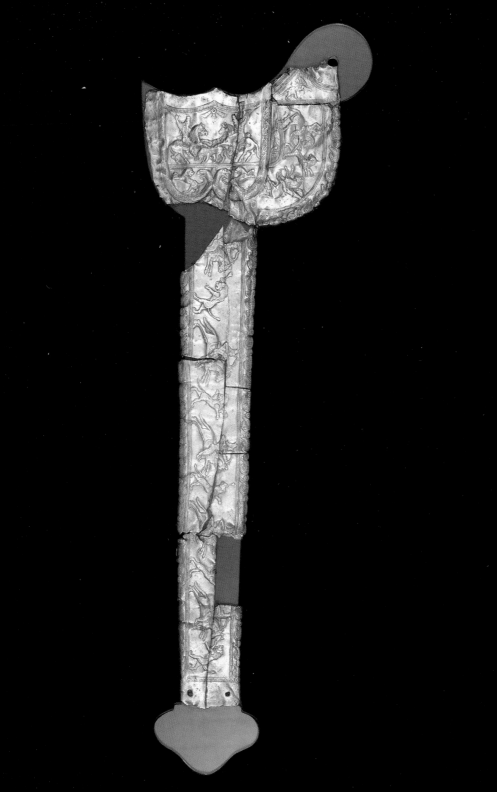

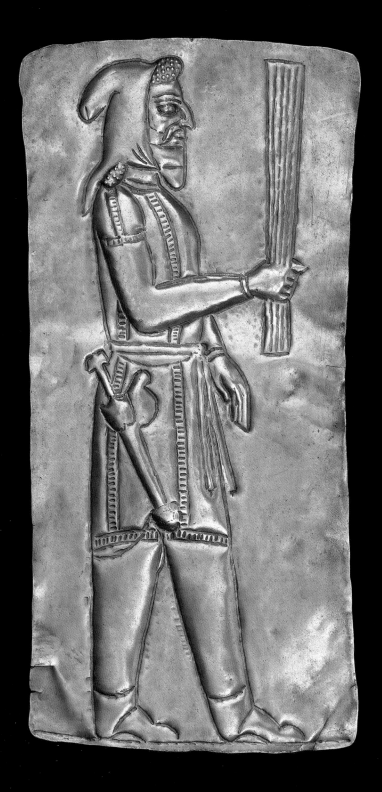

10 Gold plaque showing a figure wearing Median-style costume of short tunic and trousers with a hood, armed with a short sword and carrying a bundle of sticks (*barsom*). 5th–4th century BC. Height 15.1 cm.

sold this armlet (fig. 24, right) to the South Kensington Museum for £1,000, a very considerable sum at that time. Happily, this armlet is now reunited with the rest of the Treasure and is on long-term loan to the British Museum.

After the Treasure had been given back to them by Burton, the merchants continued on their journey to Peshawar and eventually sold the Treasure in Rawalpindi, both places now within Pakistan. The pieces were then bought from local dealers either directly by Sir Alexander Cunningham, or through intermediaries by Sir Augustus Wollaston Franks who was an avid and knowledgeable collector. Franks was later able to acquire the pieces owned by Cunningham, and when he died in 1897 Franks bequeathed to the British Museum his magnificent collections, including the Oxus Treasure. It has been on display in the British Museum almost continuously since that time. Then in 1931 and 1953 respectively, the British Museum acquired a gold rider figure (fig. 17) and a model gold chariot (fig. 14) from the Treasure that had originally been presented to the Earl of Lytton, then Viceroy of India. These were presented to Lord Lytton by Sir Louis Cavagnari, who was murdered in the British residency in Kabul in 1879, during the Second Afghan War.

Description of the Treasure

Gold plaques

Probably the most distinctive of the magnificent components of the Oxus Treasure are the fifty-one plaques made from thin sheet gold (figs 10, 12, 13 and 41). Some of the plaques were previously folded, but whether this happened in antiquity or in the nineteenth century is unknown. They are mostly rectangular in shape varying from just under 2 cm to almost 20 cm in height and have chased (incised) designs, sometimes extremely crude, that usually show human figures. The exceptions are three plaques with animal designs (fig. 13). About thirty-seven of the human figures wear the

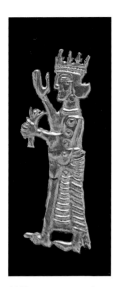

11 Dress ornament (bracteate) from the Oxus Treasure cut out from sheet gold showing a figure, probably a man, wearing a crown and a Persian-style robe and holding a flower. 5th–4th century BC. Height 6.15 cm.

so-called Median dress, the distinctive costume of the Medes that comprises a knee-length belted tunic worn in combination with trousers (figs 10, 13, 41 left and centre). The accompanying headdress is a helmet or hood (sometimes called a *bashlyk* or *kyrbasia*), probably of felt, that covers the ears and chin and has a neck guard at the back. A few of the figures wear in addition a long-sleeved overcoat (*kandys*) over the top of the belted tunic. In these cases the coat is shown draped over the shoulders with empty arms. Sometimes the Median dress is accompanied by a short Persian dagger (*akinakes*). This Median costume is often shown on the reliefs at Persepolis (fig. 3) and on small objects of Achaemenid date (sixth–fourth century BC) including some others in the Oxus Treasure. In contrast to the popularity of the 'Median' costume, only about six of the figures on the plaques wear the so-called Persian dress. This is a long robe with the folds arranged in a distinctive pattern (figs 12 and 41 right). Again, this dress is well-documented at Persepolis. Several of the figures in Persian dress are women (figs 12 and 41).

The differences between the Median and Persian forms of dress are clear but it is not certain that the wearers of the respective outfits, at least on the Persepolis reliefs, are necessarily Medes or Persians. At Persepolis the representation of the two forms of dress might be symbolic, to show Persian-Median unity.

About twenty-five of the figures in Median dress are carrying the bundles of sticks or twigs that are known as *barsoms*. These are usually associated with Zoroastrian religious ceremonies and are generally carried by priests. It does not follow, however, that all the figures on the Oxus plaques should be regarded as priests, or even that they were necessarily Zoroastrian. In this case, it may be that the barsom was simply a mark of devotion.

Although none of the six figures in Persian dress is holding a barsom, at least four of them are holding a flower, as are seven of the figures in Median dress. The significance of this flower, which may be a lotus, is not clear, but at Persepolis it is sometimes held by the king

12 Drawings of gold plaques from the Oxus Treasure showing female figures wearing Persian-style robes and carrying a lotus flower. 5th–4th century BC. Heights 4.25 cm and 4.35 cm.

himself as well as many of his courtiers.

The three plaques with animal representations show respectively a horse, a donkey with large ears, and a camel. Were it not for these animal pictures, it would be tempting to see all the plaques as votive offerings presented to a temple, either to represent the supplicants in perpetuity or to give thanks for a favour requested or received. However, it may also be possible to see the animal plaques as votive, perhaps praying for the recovery of a sick animal or anticipating reliable service in the future. The great range of quality in these plaques is perhaps another indication that they were votive: some plaques seem to have been professionally executed, but others are so crude it looks as if they were scratched by the supplicants themselves.

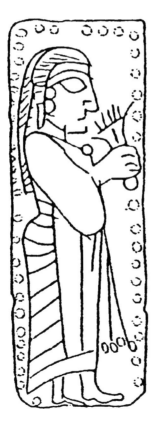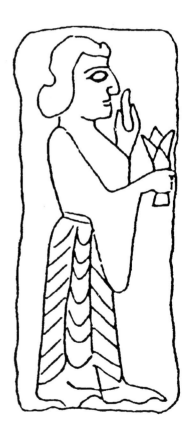

12 Drawings of gold plaques from the Oxus Treasure showing female figures wearing Persian-style robes and carrying a lotus flower. 5th–4th century BC. Heights 4.25 cm and 4.35 cm.

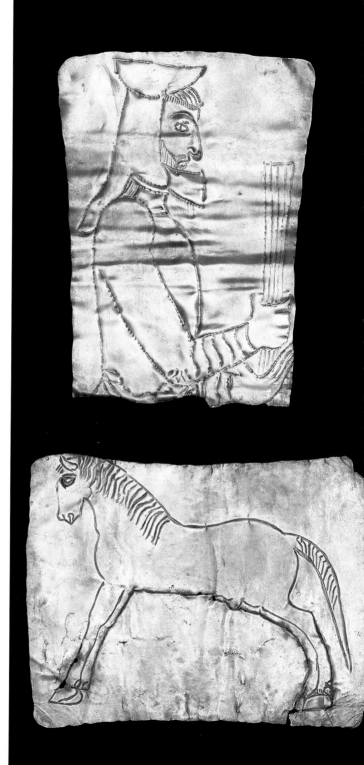

13 Gold plaques from the Oxus Treasure showing figures wearing Median-style dress of short tunic, trousers and hood, and carrying bundles of sticks (*barsoms*), and representations of horses and a camel. 5th–4th century BC. Heights 1.6 cm–9.4 cm.

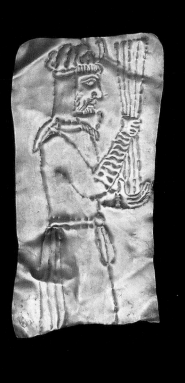

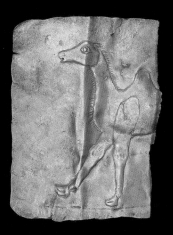

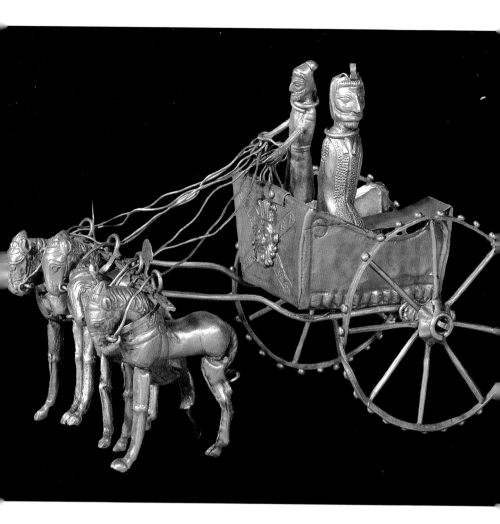

14 Gold model chariot from the Oxus Treasure pulled by four small horses. The two figures in the chariot wear Median-style costumes. On the front of the chariot is the head of the Egyptian dwarf-god Bes. 5th–4th century BC. Length 18.8 cm.

Gold chariots

One of the most outstanding pieces in the Treasure is a gold model chariot pulled by four horses or ponies (fig. 14). The chariot has two wheels, with eight and nine spokes respectively, and on the front of the cab is a representation of the Egyptian dwarf-god Bes. He was popular in the Persian Empire, usually appearing on amulets, and it is thought he had a protective function. His appearance here is a clear indication of the diversity of religions accepted within and by the empire.

In the chariot itself are two figures. The driver is standing, and holds the reins in his hands. He wears a belted tunic and trousers, and a hood with a pointed top in true Median style. The passenger is seated on a bench that runs the length of the cab. He also wears a so-called Median costume, but with the addition of an overcoat (*kandys*). Both figures have a gold wire torc around their necks. They could be Median nobles.

A second, less well preserved gold model chariot (fig. 15) was originally in the possession of the Earl of Lytton. It is now without wheels and although the driver is preserved, the seated passenger is headless. A gold horse (fig. 16) in the Franks collection in the British Museum is thought to have belonged with this chariot. Two sheet-gold cut-out figures of horses (fig. 18) were probably also parts of draught horses for a model chariot, as we know that the horses with the well-preserved chariot are hollow and made from pieces of gold sheet soldered together. No horse and rider groups are preserved in the Treasure, but there is a solid gold rider figure wearing Median costume (fig. 17) that again originally belonged to the Earl of Lytton.

15 The less well preserved gold model chariot of the Oxus Treasure, with its driver and a now-headless passenger. The chariot is without wheels. The horse pictured overleaf (fig. 16) is thought to have once belonged to it. 5th–4th century BC. Length 8.4 cm.

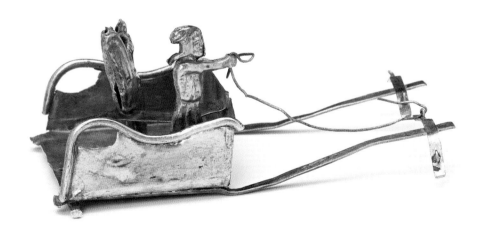

16 Gold horse thought
to have belonged
to the gold model
chariot pictured on
the previous page
(fig. 15). 5th–4th
century BC. Length
of horse 4.3 cm.

17 Solid gold male
rider figure in Median
dress with a high,
stiff cap, trousers
and a tunic. He was
probably originally
holding reins and
mounted on a horse.
5th–4th century BC.
Height 7.6 cm.

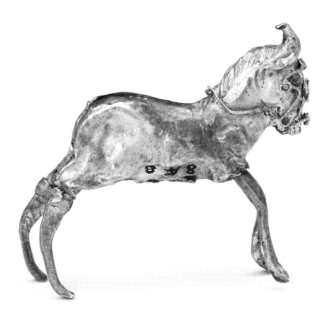

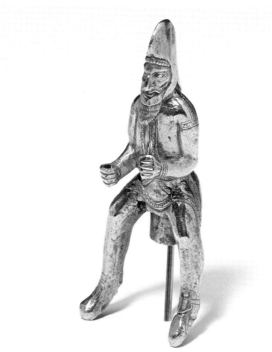

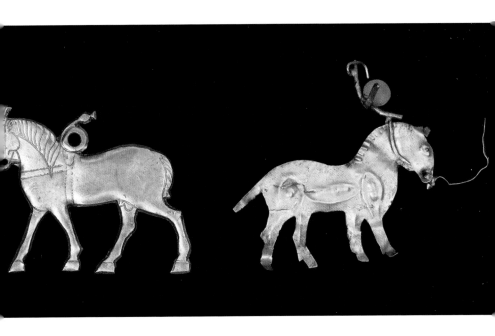

Figurines

18 Two sheet-gold cut-out figures of horses with punched and embossed details, possibly draught horses for other chariot models. 5th–4th century BC. Lengths 5.25 cm and 5.5 cm.

Other figures belonging with the Treasure are now freestanding, although they may originally have been part of larger compositions. Two small solid gold statuettes (fig. 20) show figures each wearing a Median-style trouser suit with an overcoat (*kandys*) draped over the shoulders, leaving the sleeves empty. They each wear a helmet (*bashlyk*) that covers the ears and chin and hold a bundle of sticks (*barsom*) in their right hand. A larger silver statuette (fig. 19), partially gilded, shows a figure wearing a pleated robe in Persian style. On his head is a cap which is decorated with a band of incised crenellations around the top, which has led to suggestions that he might be a king. He is also carrying a bundle of sticks (*barsom*). This figure is bearded, but otherwise his face is uncovered. Another large silver statuette is of a quite different type. This shows a youth with fists clenched, completely naked except for a tall, domed hat that is covered with gold foil (fig. 7). Hats of this kind can be seen on the Persepolis reliefs and on figures from Lydia in western Turkey, then part of the

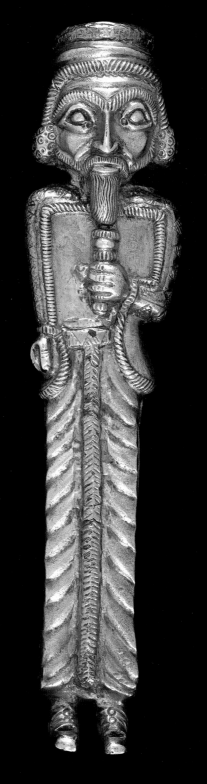

19 *Left* Silver statuette of a bearded male figure wearing a pleated Persian-style robe and a cap with incised decoration showing crenellations. He holds a bundle of twigs (*barsom*) in his left hand. This figure is partially gilded. 5th–4th century BC. Height 14.8 cm.

20 *Right* Two solid gold statuettes showing figures wearing Median-style trouser-suits and hoods with overcoats. They carry bundles of twigs (*barsoms*) and masks cover their mouths. 5th–4th century BC. Heights 5.3 cm and 5.6 cm.

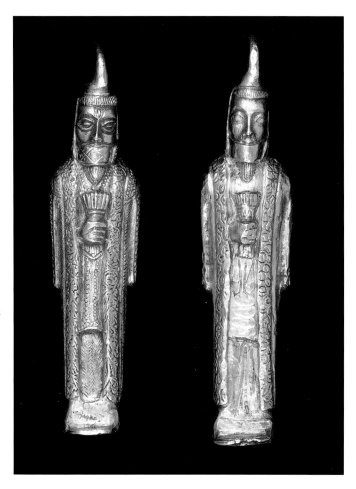

Achaemenid Empire, but nudity is unusual in the art of the Ancient Near East and perhaps indicates Greek influence. This enigmatic figure is mounted on a square, stepped base. Again different is a large hollow gold head showing a beardless boy with short wavy hair and ears pierced for earrings (fig. 6). This was possibly part of a composite statue made of different materials including wood. The workmanship as well as the artistry is crude, and this head might have been locally produced, as we would expect art objects from one of the major Persian centres to be of a higher quality.

21 *Below* Drawing of the gold scabbard cover (see fig. 9) showing in the wide upper part four riders on horseback attacking lions with long spears, while the long, narrow part of the scabbard has a further five horsemen and lions arranged in a line.

22 and 23 *Opposite* The drawing on the left shows the king's weapon-bearer depicted on the Apadana reliefs at Persepolis. The bow-case has a bird's head ornament at the top, similar to the gold plaque on the right. The plaque, in the shape of a bird's head, has five loops for attachment 5th–4th century BC. Length 3.35 cm.

Scabbard and bow case

A gold scabbard cover for a Persian dagger (*akinakes*), one of the highlights of the Treasure, was partly mutilated probably in the 19th century (*see* figs 9 and 21). The bottom of the scabbard (chape) is now missing. The thin gold, which was originally mounted on another material such as wood or leather, is embossed with scenes showing riders on horseback battling with lions, who are either shot with arrows or attacked with spears. In recent years, there has been much debate about the date of this scabbard cover. Because the hunting scenes are vaguely reminiscent of Assyrian reliefs from the time of Ashurbanipal (King of Assyria 668–627 BC), and because the horsemen, although wearing trousers in the Iranian fashion, have fez-like hats similar to those worn by Assyrian kings, many scholars have seen this scabbard as one of the earliest pieces in the Oxus Treasure, perhaps even dating from the pre-Achaemenid-Median period. However, other scholars have argued for a date not earlier than the time of Darius (522–486 BC), citing iconographic details such as the form of the winged disc above the pair of horsemen attacking a

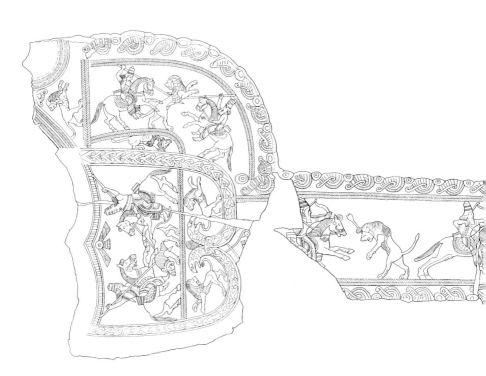

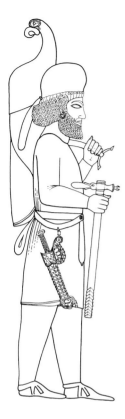

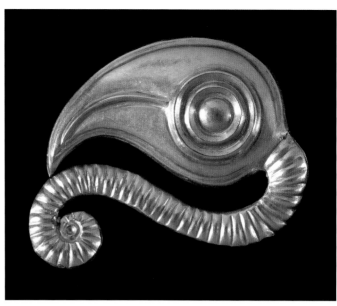

lion. Whatever the exact date of this scabbard, however, its decoration is a wonderful example of miniature art, with the scenes being depicted in extraordinarily intricate detail.

Another of the most magnificent and distinctive pieces, also from a piece of military equipment, is a gold cut-out plaque (fig. 23) in the shape of a bird's head. This was probably fixed to the top of a bow-case (*gorytus*), as seen on the Persepolis reliefs (fig. 22).

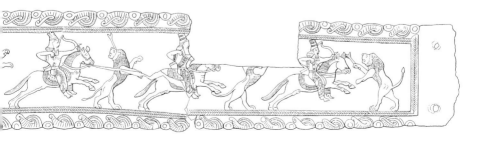

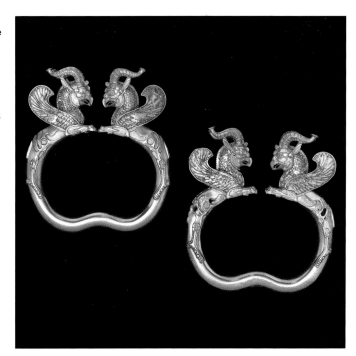

24 The two massive gold armlets from the Oxus Treasure with terminals in the form of winged griffins. They were originally inlaid with coloured glass, faience and semi-precious stones such as turquoise, lapis lazuli and carnelian. The armlet on the right was purchased from the robbers by Captain Francis C. Burton. 5th–4th century BC. Heights 12.8 cm and 12.4 cm.

Armlets, bracelets and torcs

Amongst the best known objects in the Treasure is a pair of massive gold bracelets or armlets with terminals in the form of horned, winged griffins (fig. 24). There are cells or *cloisons* for polychrome inlays on the heads, necks, wings and horns, and larger cavities for inlay on the bodies of the animals. A few of the smaller inlays survive. Inlaid polychrome decoration, in which stones such as turquoise, lapis lazuli and carnelian are combined with faience (a glazed composition) and coloured glass, is a hallmark of the fine jewellery of the Achaemenid period, and such pieces would have been dazzlingly colourful when they were new. Large animal-headed bracelets are shown being presented to the king by four of the delegations on the Apadana reliefs at Persepolis (fig. 25), and according to the ancient Greek historian Xenophon (in the *Anabasis*), were amongst the gifts that were especially prized at the Persian court.

In addition there are half a dozen spiral gold bracelets or torcs with terminals in the form of animal heads – lions, rams and goats – as well as eleven gold bracelets with abutting terminals in the form of winged goats and bulls, as well as the heads of lions, rams, goats, ducks and lion-griffins (figs 26 and 27). Some of these bracelets have cavities for inlay, and in one case pieces of the semi-precious stone turquoise are still preserved (fig. 40). In a few cases the terminals have been cut off the original hoops and remounted on modern silver or gold hoops, for reasons explained on pp. 19–20. A particularly interesting pair of bracelets has terminals in the form of monstrous animals with long snouts, triangular-shaped eyes and long tails which interlock at the back of the hoop (fig. 27). These bracelets seem to be related to the Scythian-style art of western Siberia.

25 Stone relief on the east side of the Apadana at Persepolis showing armlets with griffin terminals being carried by a member of Delegation VI (Lydians).

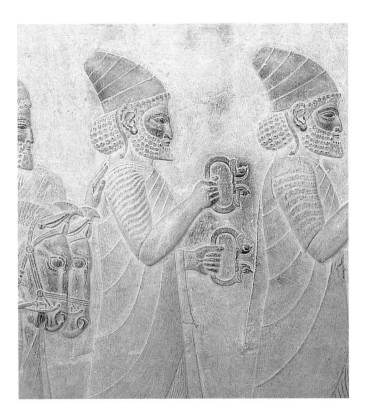

26 Gold bracelet from the Oxus Treasure with terminals in the form of bulls. Part of the hoop is modern. 5th–4th century BC. Diameter 5.55 cm.

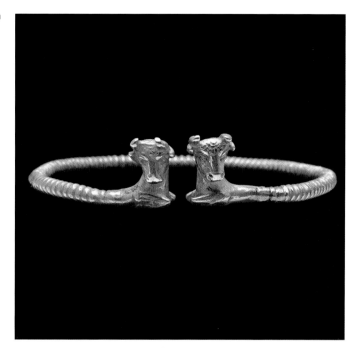

27 Pair of solid gold bracelets from the Oxus Treasure decorated with dragons. The monsters have heads with long snouts and rows of teeth, and long tails which interlock at the back of the hoop. This style of decoration is reminiscent of the art of the Caucasus or western Siberia. 5th–4th century BC. Diameter of each 7.9 cm.

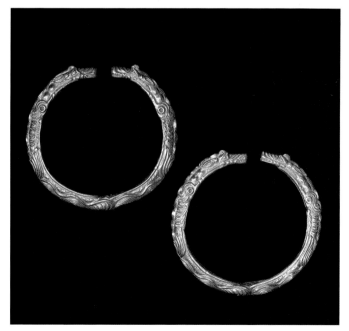

28 *Right* Gold finger-ring from the Oxus Treasure with relief decoration showing the coiled figure of a lion. There are cavities for inlays that are now missing. The twisted animal is typical of the animal-style art of south Russia. 5th–4th century BC. Diameter of bezel 2.65 cm.

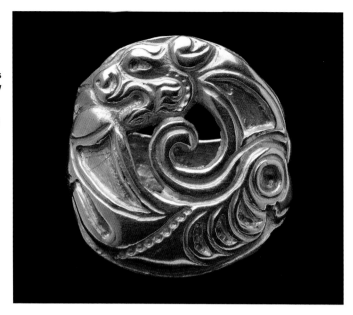

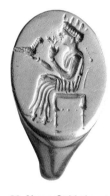

29 *Above* Gold signet-ring from the Oxus Treasure with intaglio (incised) design showing a figure, probably female, seated on a chair with a high back. The figure wears a crown and holds a bird in one hand and a flower in the other. 5th–4th century BC. Height of bezel 1.9 cm.

Finger-rings, stamps and seals

The Oxus Treasure also includes twelve gold finger-rings with bezels (the circular or oval flat part of the ring) engraved with designs that include animals, a figure seated on a throne and the Greek hero Heracles, shown naked. These are signet-rings and would have served the same purpose as a stamp seal made from chalcedony (fig. 30) and two cylinder seals that are also associated with the Treasure (figs 31 and 32). Three of the signet-rings (*see* fig. 29) and one of the cylinder seals show women, which is unusual, as women are only rarely depicted in the art of the Achaemenid period. One heavy gold finger-ring is of particular interest in that the bezel has cavities for inlays and is decorated in relief with the coiled figure of a lion (fig. 28). There may be Scythian influence here, as twisting the bodies of animals into impossible circular shapes is a characteristic of Scythian art.

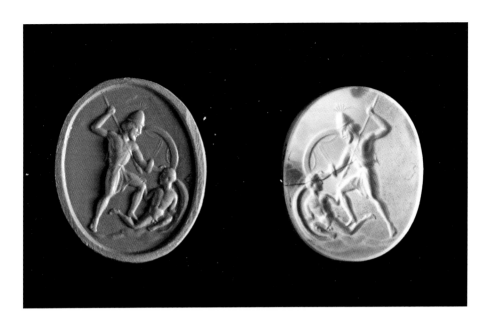

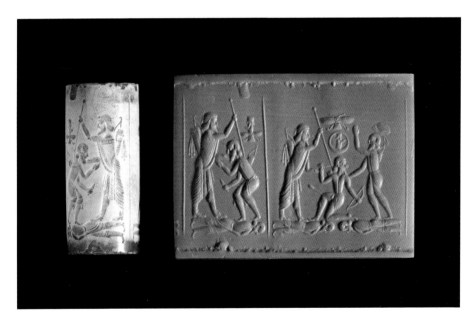

30 Left Blue chalcedony stamp seal and modern impression showing a soldier wearing a crested Greek helmet with a spear in his right hand and a shield in his left, vanquishing a fallen naked enemy. 5th–4th century BC. Length 2.45 cm.

31 Below Blue chalcedony cylinder seal and modern impression with two scenes showing a figure in Persian dress, probably the king, armed with a long spear and fighting opponents who wear knee-length tunics and boots. Three of the enemies have already been slain. Above the scenes are figures that have been variously interpreted as Ahuramazda, the divine glory, or the deified king. 5th–4th century BC. Height 3.7 cm; diameter 1.1 cm.

32 Above right Carnelian cylinder seal and modern impression showing a seated figure with, in front of him, a naked woman with plaited hair hanging down her back and behind him a zebu. The meaning of the three Aramaic letters above the figures is unclear. 5th–4th century BC. Height 3.9 cm; diameter 1.3 cm.

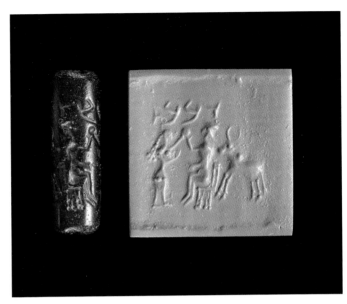

Vessels

The vessels in the Treasure include a gold bowl which is decorated on the underside with pairs of embossed lions standing on their hind legs, separated by almond-shaped lobes (fig. 34). Dalton compared these lions with those on the scabbard (figs 9 and 21), and thought this bowl might therefore be of similarly early date, but the shape of the bowl is classic Achaemenid (*see* p. 53). A shallow silver bowl has an embossed flower or rosette in the centre with fluted decoration in the form of radiating petals, and a gold jug has a lion's head at the top of the handle (fig. 33). Two of the gold bowls in the Treasure are quite plain. A silver gilt figure of a leaping ibex (fig. 36) is one of the two handles from a vase or amphora, probably of the same metal. Such vessels are shown on the reliefs at Persepolis being presented to the king by several of the delegations from different parts of the empire (fig. 43), another indication of the

33 Gold jug from the Oxus Treasure with a ribbed body and handle ending at the top in a lion's head. 5th–4th century BC. Height 13.0 cm.

34 Underside of a shallow gold bowl with embossed decoration showing almond-shaped lobes and winged lions standing on their hind legs. 5th–4th century BC. Diameter 12.1 cm.

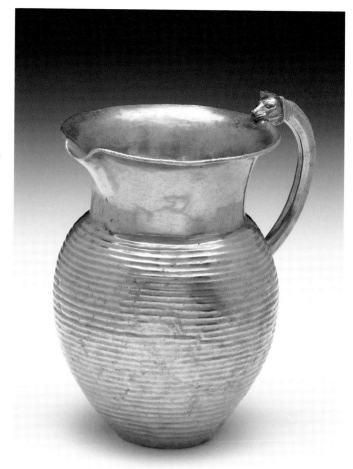

wealth of the Persian court, which was legendary in the ancient world. This wealth is often commented upon by classical authors. Thus, the ancient Greek historian Herodotus (c.490/480–425 BC) tells us that after the Greek victory at Plataea, the tents of the vanquished Persians were found to be full of, amongst other things, 'bowls, goblets, and cups, all made of gold'.

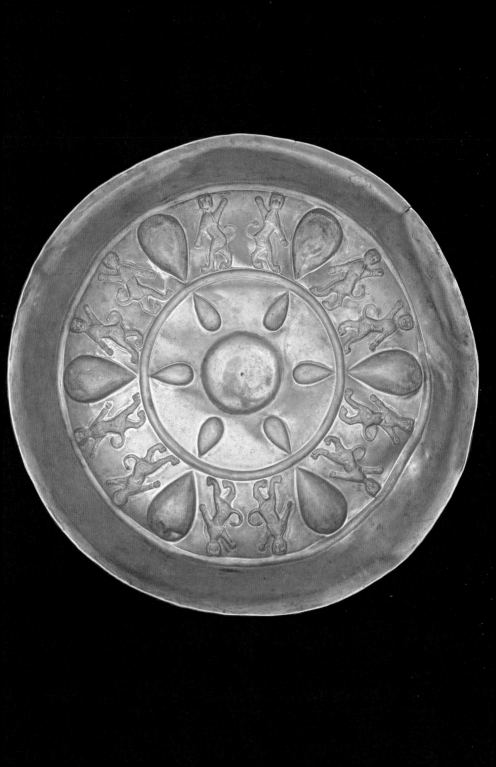

36 *Opposite* Silver vase handle in the form of a leaping ibex. This handle was originally gilded. 5th–4th century BC. Height 21 cm. Similar vase handles are shown on the Persepolis reliefs (fig. 43).

A curious gold fish with a hollow centre and a hole in its mouth (fig. 35) might also originally have been a vessel, but we do not know what sort of liquid it might have contained.

The images that are found on these vessels and indeed on other objects in the Treasure – such as lions, rams, goats, ibexes, lotus flowers and rosettes – are all motifs that feature heavily in Persian art. Their precise significance, however, is often unclear.

Bracteates

In the Ancient Near East it was a common practice to decorate clothes with thin gold plaques (bracteates), and more than a dozen circular gold plaques in the Oxus Treasure probably served this purpose (figs 1, 37, 38). They are usually perforated with holes around the edge or have loops at the back so that they can be sewn on to clothes. The embossed designs on these plaques include sphinxes, winged lions and a head of Bes (fig. 42), the Egyptian dwarf-god known for his protective qualities. A figure of

35 Hollow gold fish with a hole in the mouth and a loop for suspension above the left fin. This is apparently a type of carp only found in the River Oxus. It might have belonged to a composition consisting of a group of pendants, or it might have been a container for oil or perfume. 5th–4th century BC Length 24.2 cm.

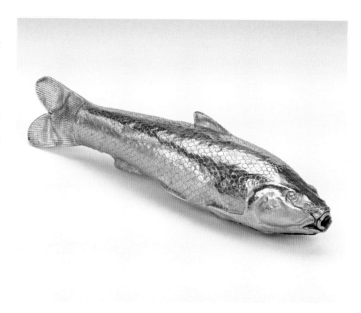

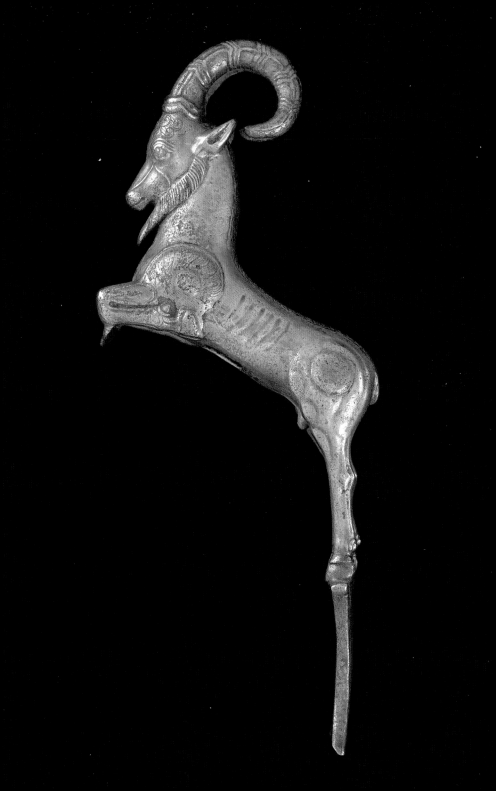

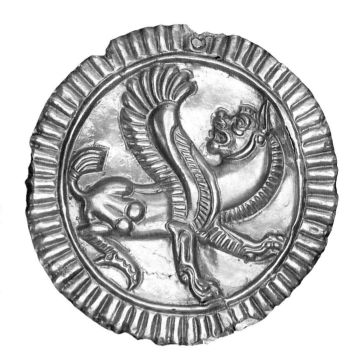

37 *Right* Circular gold plaque from the Oxus Treasure, probably a clothing ornament, with embossed decoration showing a lion-griffin. There are four hoops on the back for attachment. 5th–4th century BC. Diameter 4.75 cm.

38 *Opposite* Gold ornament from the Oxus Treasure in the form of a monstrous animal with wings, the head of a roaring lion, the horns and body of an ibex, pointed ears and wings. The tail ends in a leaf shape. There are cavities for inlays that are now missing. At the back of the ornament are two long prongs for attachment, perhaps to wood or bitumen. The purpose of this object is unknown, but the style recalls the animal-style art of south Russia. 5th–4th century BC. Length 6.15 cm.

a beardless man wearing a crown cut out from gold sheet was probably also a dress ornament (fig. 11).

Two other gold roundels are probably decorations for horse harnesses (*phalerae*); one shows a pair of recumbent boars and the other shows the head of a roaring lion. Both pieces show some affinities with Scythian art. Probably also a horse harness ornament (although it has sometimes been interpreted as a shield-boss) is a large silver gilt disc with a circular composition showing horsemen hunting ibexes and deer. The clothing of the horsemen depicted here indicates that the style of this disc, however, is Achaemenid as it is on another probable item of harness, a large gold disc with embossed decoration showing an eagle and lotus flowers.

Scythian influence (*see* p. 54) is also evident in a splendid gold ornament in the form of a fabulous creature with the body of a winged goat and the head of a horned

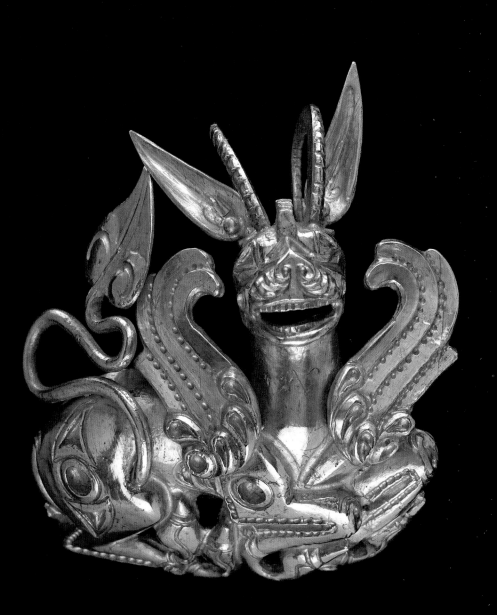

39 *Opposite* **Front and back sides of coins thought to be associated with the Oxus Treasure.** *From top to bottom* **A gold double Daric (4th century** BC**) and silver coins of Alexander the Great (***c.***331–323** BC**), Seleucus (***c.***312–281** BC**) and Diodotus** *c.***255–239** BC**). Diameters: 19 mm; 33 mm; 25 mm and 34 mm.**

lion (fig. 38). This composite beast has its legs folded beneath it in the 'animal style' associated with the steppes of south Russia. There are two long prongs at the back for attachment. Its most likely purpose was as a hair or cap ornament.

The Oxus coins

Originally about 1500 coins were said to belong with the Oxus Treasure, but most of these cannot now be identified. There are however about 200 coins in the British Museum (fig. 39) and in other public collections, such as the State Hermitage Museum in St Petersburg, Russia, that may have been part of the Treasure, but their definite association has not been accepted by all scholars. However that may be, the coins include examples from mints around the Persian Empire as well as from the reigns of Alexander the Great (331–323 BC), who conquered the empire, and the Seleucid dynasty rulers who succeeded him. Sir Alexander Cunningham who made a special study of the coins, concluded that they covered a period of about 300 years from the time of Darius the Great (522–486 BC) to the reigns of Antiochus the Great (223–187 BC) and Euthydemus I of Bactria (*c.*235–200 BC).

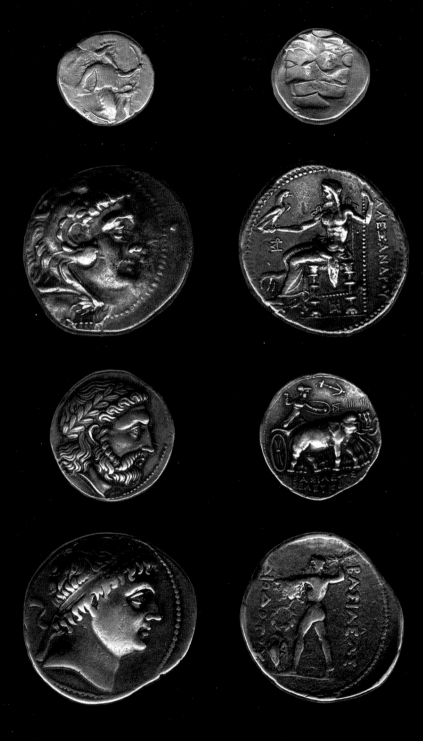

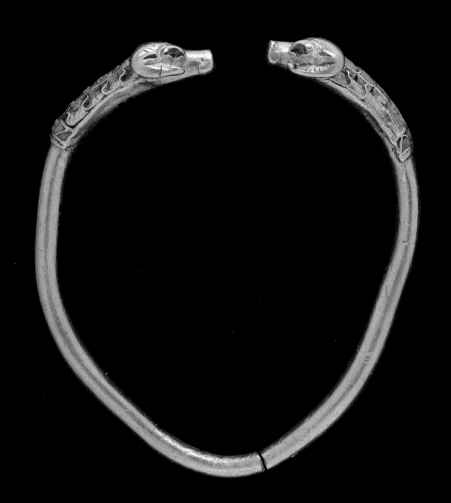

Technical analysis of the Treasure

40 Gold bracelet from the Oxus Treasure with ram's head terminals. The heads and necks of the animals have cavities for inlay, some of which still contain pieces of turquoise. 5th–4th century BC. Diameter 7.25 cm.

Non-destructive analysis of the surface of thirty-eight of the fifty-one gold plaques in the Treasure suggests that alluvial gold (obtained from riverbeds), alloyed with a little copper and possibly silver, was used for many of the plaques. Platinum inclusions, which are associated with alluvial gold and are usually indicative of early goldwork, were found in the majority of the plaques, sometimes in high levels. The likelihood, therefore, is that most of the plaques were made from alluvial gold that could have been obtained from the upper reaches of the River Oxus where it is known to occur. Some of the plaques, however, and also other items in the Treasure, might have been made from recirculated or previously refined gold, as was often the case in the Ancient Near East. A recent and extensive analytical investigation of the gold chariot (fig. 14) has confirmed the earlier findings, showing that the gold used was almost certainly alluvial gold containing silver to which copper was deliberately added, producing an average alloy of 91% gold with 5% silver and 4% copper.

The range of techniques used to produce the objects in the Oxus Treasure shows that Achaemenid goldsmiths had sophisticated technical knowledge and were highly skilled, although we know little about who they were and how they were organized. Objects were produced by lost-wax casting or hammering, or by combining the two techniques. Hammered sheets of gold were decorated with embossed (*repoussé*) and chased designs. Pieces of gold were joined by rivets or by solder. In the latter case, a gold alloy with a lower melting point than the base metal was used for soldering. We have already noted that inlaid polychrome decoration (fig. 40) was a characteristic feature of fine Achaemenid jewellery. In this technique, gold was inlaid with coloured semi-precious stones, glass or faience (glazed composition). These inlays were fixed either into prepared cavities or into 'cloisons' that were created by soldering thin strips of gold on to the surface of the object. The inlays were sometimes held in place with bitumen (a sticky, tar-like substance). Other techniques include

granulation (the application of tiny balls of gold) and the use of twisted wire (filigree). The Achaemenid goldsmiths possibly also employed the lathe, as suggested by the existence of a central point on the base of some gold vessels where they were fixed to the turning spindle of the lathe.

The authenticity of the Treasure

Because the Oxus Treasure was not recovered in a proper archaeological excavation, and because of the bizarre circumstances surrounding its discovery, it is sometimes suggested that some of the pieces might be nineteenth century fakes, produced by goldsmiths in Rawalpindi. In fact, we know that after the discovery of the Treasure some forgeries were definitely being produced. Thus, Dalton tells us that a chalcedony cylinder seal showing a Persian king vanquishing his enemies, a silver disc with a hunting scene, and the silver vase handle in the form of a leaping goat (fig. 29) were all copied in gold, apparently in Rawalpindi. However, these were swiftly recognized at the time as copies and denounced as such. According to Dalton, Franks had no difficulty in distinguishing them from the original pieces. Apart from these pieces, which were never regarded as being part of the Treasure, there is no good reason to suppose that any of the pieces now belonging to the Treasure are of recent manufacture. In fact, the passage of time, with the emergence of more ancient parallels and more sophisticated scientific investigation, has served only to confirm the authenticity of nearly all the pieces.

The art of the Achaemenid Persian Empire

The Oxus Treasure is often regarded as the finest collection of gold and silver objects to have survived from the Achaemenid period, but how much do we know about the art and material culture of the ancient Persian Empire? Much of what we know about Persian material culture

derives from Persepolis, where there are still standing a series of palaces with carved stone reliefs showing in great detail various ceremonies that evidently took place at this important site. We see, for example, processions in which alternate figures wear Median or Persian costume. Of particular interest and importance are the reliefs on the north and east sides of the Apadana (the Audience Palace), that are mirror images of each other (*see* fig. 3). They show guards, files of nobles, attendants, chariots for the use of the king (rather like the Oxus Treasure model, fig. 14) and twenty-three delegations from around the empire bringing presents for the king. It is sometimes claimed that these are depictions of a ceremony that took place at the time of the spring equinox (*Nowruz*), but this remains unproven. Each delegation, consisting of about half a dozen people dressed in their national costume, is introduced by an usher in Persian or Median costume. They bring presents that are sometimes but not always characteristic of their native region, such as a two-humped camel from Bactria and lion cubs from Elam in south-western Iran. Other gifts seem to be representative of luxury items that are in circulation throughout the Persian Empire, such as animal-headed bracelets and vases with animal-shaped handles (fig. 43), which have parallels in the Oxus Treasure (fig. 36). A number of delegations bring bowls presumably of gold and typical Achaemenid shape, with carinated (ridge-shaped) sides and flared rims, again like several of the examples in the Oxus Treasure. Short swords in scabbards comparable to the Oxus Treasure example (figs 9 and 21) are being both worn and presented.

It has often been remarked that the artistic and architectural styles of the Persian Empire were eclectic, with inspiration having been drawn from many different quarters. It is certainly true that there were varying degrees of influence from Assyria, Babylonia, Egypt, Elam and elsewhere, but these different styles were brought together and synthesized to produce a style that is distinctively Achaemenid-Persian. In this style, inspiration from Iran itself predominated, but foreign influences, although modified, are clearly visible. The eclectic nature

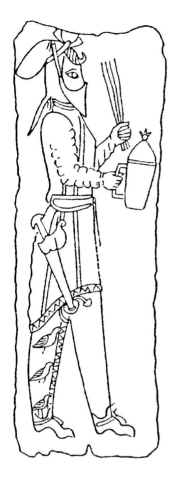
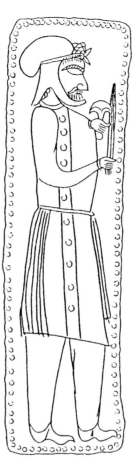
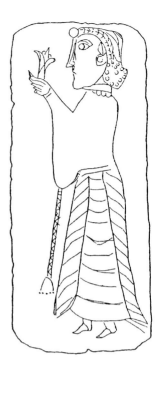

41 Drawings of gold plaques from the Oxus Treasure, two showing men wearing Median-style trouser-suits with hoods and the third showing a woman wearing a Persian-style robe. The men carry bundles of sticks (*barsoms*) and the woman carries a flower. 5th–4th century BC. Heights 6.7 cm, 20 cm and 7.65 cm.

of Persian art is particularly clear at Persepolis, with Assyrian-style gateway figures, Egyptian-inspired columns and Persian architectural planning.

Occasionally, however, foreign motifs are imported with little or no modification. We see this, for example, with the representations of the Egyptian dwarf-god Bes, that are found on the Oxus Treasure chariot (fig. 14) and on a gold roundel (fig. 42). There is also in Achaemenid art some clear Scythian influence. The Scythians were a contemporary nomadic people speaking an Iranian language, who inhabited the steppes of south Russia. They are renowned for their so-called 'animal-style' art, in which

animals are often stylized and twisted into fantastic shapes (*see* figs 27, 28 and 38).

If the styles of art and architecture were eclectic, however, the religion was Iranian in inspiration. The Persian kings themselves paid homage to the god Ahuramazda, the principal god in the Zoroastrian religion. However, it is uncertain whether the Persian kings knew of the teachings of Zoroaster, an eastern Iranian prophet who flourished around 1000 BC and gave his name to the religion. For this reason, the Achaemenid kings are often referred to as 'Mazda-worshippers'. Zoroastrianism believes in a conflict between good (represented by Ahuramazda) and evil (represented by Ahriman). It eventually became the state religion of Iran in the Sasanian period (third–seventh century AD). Traces of the Zoroastrian religion usually include temples in which fire was worshipped. These were known as fire temples. As we shall see, it is likely that the items in the Oxus Treasure were presented to a temple, but even though many of the gold plaques seem to show priests, it would be rash to

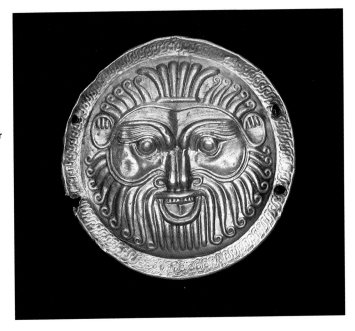

42 Circular gold plaque from the Oxus Treasure, probably a clothing ornament, with embossed decoration showing the head of the Egyptian dwarf-god Bes. There are four holes around the edge of the plaque for attachment. The head of Bes is also shown on the gold chariot (fig. 14). 5th–4th century BC. Diameter 4.35 cm.

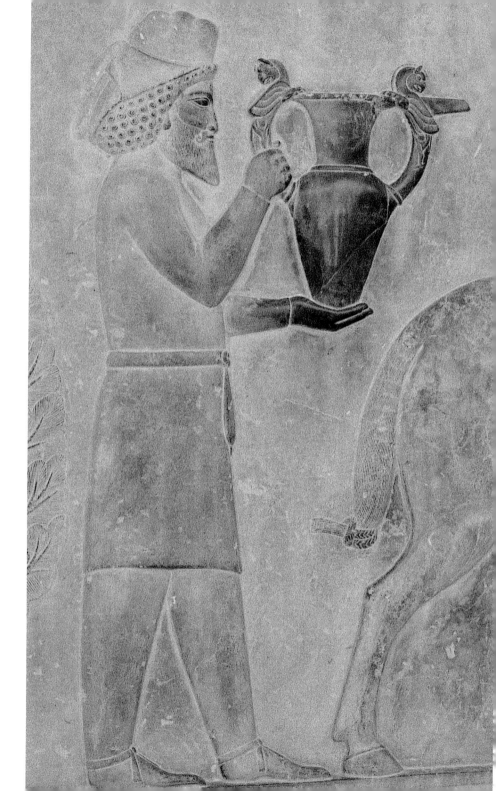

43 Stone relief on the east side of the Apadana Palace at Persepolis showing a gold or silver vase with handles in the shape of winged griffins being carried by a member of the Armenian Delegation. There is a similar vase handle in the Oxus Treasure (fig. 36)

assume they were Zoroastrian at this early date.

The reliefs at Persepolis provide a wonderful visual record of the material culture of the Persian Empire, but Persepolis itself was thoroughly looted by Alexander and his Macedonian troops in 331–330 BC, and only a fraction of the valuable treasure that must have been at the site has been recovered from excavations. There are sporadic finds at other sites in Iran, such as a rich burial at Susa and a small hoard of jewellery at Pasargadae, but nothing comparable with the Oxus Treasure. Increasingly, finds from around the empire, such as in Bulgaria, western Turkey and the Caucasus, are providing evidence for the sumptuous plate, furniture and jewellery that must have been commonplace at the Persian court, but the Oxus Treasure still retains its importance as one of the largest assemblages of Achaemenid period objects in precious metal. It provides a tantalizing glimpse of the wealth that we know must once have existed in Persia, and is indicated by classical authors when describing the amounts of booty seized at the Persian capitals by Alexander's troops. According to the Roman historian Plutarch (*c.* AD 46–120), Alexander carried away the treasure of Persepolis on 20,000 mules and 5,000 camels. Even though this is probably an exaggeration, it is indicative of the scale of the plunder.

Dating the Treasure

It is important to stress here that the Oxus Treasure was not recovered in a properly controlled archaeological excavation, and therefore we can never be quite certain that all the pieces belong together and that there are no fakes amongst them. Having said that, the available evidence seems to suggest that all the pieces now associated with the Treasure are of ancient manufacture and they have enough in common to suggest that they might all have been found together as indicated in contemporary nineteenth-century reports. The majority of the pieces clearly date from between the fifth and fourth centuries BC, with just a few that may be earlier or later than this. This means that they are from the Achaemenid-Persian period, and

many of the pieces are classic examples of the art of this time. As noted on p. 48, the coins (if they all really belong with the Treasure) covered a period of about 300 years down to the reigns of Antiochus the Great (223–187 BC) and Euthydemus I of Bactria (*c*.235–200 BC). This led Sir Alexander Cunningham to conclude that the Treasure must have been 'sealed' in *c*.200–180 BC, by which time the area of Takht-i Kuwad would have been part of the Graeco-Bactrian kingdom that followed the Achaemenid Empire in this part of Central Asia. None of the objects in the Treasure, however, seem to be as late as this.

What can we deduce from the Treasure?

Perhaps the most burning question is what does the Treasure represent and why were the objects collected together? We have already suggested that the fifty-one gold plaques mostly with human representations were votive, that is, they were presented to a temple or a sanctuary to stand in for the donor, either asking or giving thanks for a favour. It is conceivable that the other objects in the Treasure were also presented to a temple. There are many examples of ancient shrines to which people presented objects in precious metal and coins, and it seems likely that in the Oxus Treasure we have just such a collection of objects, presented to a temple over a period of several centuries.

What else can we deduce from the Oxus Treasure? We have already seen that nineteenth-century accounts localize the find-spot as Takht-i Kuwad, a crossing point on the north bank of the River Oxus. This site is located a short distance (about 7–8 kilometres) downstream from the confluence of the rivers Vakhsh and Pyandzh, which come together to form the River Oxus. The site is now represented by a mound, on the top of which has been built a frontier post. Interestingly, Takht-i Kuwad is about 5 kilometres south of the citadel of the now famous site of Takht-i Sangin, where excavations have been in progress since 1976. A Soviet expedition led by B. A. Litvinsky and

I. R. Pichikiyan worked at the site between 1976 and 1991, and since 1998 excavations have been directed by Angelina Drujinina on behalf of the Tajik Academy of Sciences and the German Archaeological Institute. On the citadel at Takht-i Sangin is a monumental building which has been identified as a temple.

The central columned hall of this temple was surrounded by store-rooms containing more than 5,000 objects which had presumably been dedicated to the temple. This collection of objects includes weapons, coins, jewellery and portrait busts in clay and stucco. Amongst the outstanding items are a miniature altar with a dedicatory inscription surmounted by a figurine of Silenus-Marsyas (the god of the Oxus), an ivory scabbard for an *akinakes* (dagger or short sword) carved with the figure of a lion, an elaborate ivory chape from a scabbard showing a fantastic creature which is part horse and part mermaid (*hippocamp*), and the front part of an ivory lion from a rhyton (a horn-shaped drinking vessel). There are also three gold votive plaques. One of them is apparently undecorated, another shows a winged creature and the third, which is inlaid with paste and carnelian, depicts a man leading a camel. In the view of Litvinsky and Pichikiyan, the temple was built about 330–300 BC, as shown by the style of the Greek Ionic column capitals that can be paralleled in buildings in Asia Minor from this period, for example the Temple of Artemis-Cybele at Sardis. They believe that the objects deposited in the temple range over a very wide period from the sixth century BC right down to the second or third century AD.

The Russian excavators believed that some of the features they uncovered were fire altars and therefore identified the building as a fire temple, in which case it would have had connections with a form of the Zoroastrian religion. However, other scholars are sceptical about the interpretation as a fire temple and believe it is more likely the temple was dedicated to the god of the River Oxus.

In view of the proximity of Takht-i Sangin and Takht-i Kuwad, and some perceived similarity between the Oxus Treasure and the hoard found at Takht-i Sangin, there

have inevitably been suggestions that the Oxus Treasure in the British Museum originally came from Takht-i Sangin. This is certainly not impossible as it is now clear that the citadel at Takht-i Sangin is at the centre of a very extensive site which extends to within a few kilometres of the border post at Takht-i Kuwad, and the nineteenth-century accounts are not sufficiently specific to exclude a find-spot somewhere within this general area. Also, the name of Takht-i Sangin is entirely modern, having been invented by Pichikiyan in the 1980s, and it is possible that in the nineteenth century the name of Takht-i Kuwad covered a wider area than it does now. However, even if the Oxus Treasure was found somewhere within the extensive site of Takht-i Sangin, it seems unlikely that it could have come from the temple that has been excavated in the citadel. This is because although the dates of the two collections overlap, it is suggested that the Oxus Treasure might have been sealed in the early second century BC, whereas the latest objects from Takht-i Sangin are second or third century AD. Secondly, while it is true that three gold 'votive' plaques have been found at Takht-i Sangin, neither in style, technique or subject matter are they exactly the same as the Oxus Treasure plaques.

At the moment we can go no further than to say the Oxus Treasure was found in the general area of Takht-i Kuwad and Takht-i Sangin – we cannot be more precise than this. It is to be hoped that further archaeological work in the area will cast light on this important question. In the meantime, all we can say is that the character of the Treasure strongly suggests that it was a temple hoard made up of precious objects donated over a period of time. Similar hoards are attested elsewhere in Central Asia, for example at Mir Zakah in Afghanistan, where we have a similar mixture of jewellery, precious objects and coins. It is tempting to suggest some link between the votive character of the Treasure and the possible location of a temple close to a crossing-point of the Oxus, but this is speculation. Nevertheless, it remains possible that objects may have been dedicated to a temple in thanks for (or in expectation of) a safe crossing of the river. Such an

interpretation would, however, perhaps be at odds with the possible Zoroastrian associations of the Treasure. For the time being, these intriguing questions have to remain unanswered.

Although the Oxus Treasure has been known for more than 130 years, there is still much about it that remains mysterious. What is clear, however, is that in the Treasure we have a remarkable legacy from the Achaemenid period. The wide range of the pieces, and the high quality of some of them, makes the Oxus Treasure still the most important collection of gold and silver objects to have survived from ancient Persia. In the Treasure we can see different types of object that are typical of the material culture of the period, and we can also see evidence for the different artistic influences that inspired the Achaemenid style. When we add to this the figural representations and the technical expertise involved in making some of the pieces, it is clear that the Oxus Treasure has the capacity to tell us much about the art and culture of ancient Persia. However, there are some puzzling features. One is the great difference in the quality of craftsmanship between the finest pieces such as the gold chariot (fig. 14) and the crudest pieces such as some of the gold plaques shown in fig. 13. This could reflect the relative affluence of the donors to a temple, but at the moment it remains speculative that the objects were presented to a temple. Nor do we know what sort of temple it might have been, who the supplicants were or where they came from, or even where the objects were made, other than broadly within the Persian Empire. These questions will hopefully be answered in due course, partly through excavation and survey in the area of Takht-i Kuwad, but in the meantime it is gratifying that ongoing scientific research is steadily providing evidence that the Treasure is an authentic collection of unparalleled riches from the Persian Empire.

Further reading and web resources

J. E. Curtis, A. Searight and M. R. Cowell, 'The gold plaques of the Oxus Treasure: manufacture, decoration and meaning', in T. Potts, M. Roaf and D. Stein (eds), *Culture through Objects: Ancient Near Eastern Studies in Honour of P.R.S. Moorey*, Oxford, 2003, pp. 219–47

J. E. Curtis and N. Tallis (eds), *Forgotten Empire: The World of Ancient Persia*, London, 2005

J. E. Curtis, 'The Oxus Treasure in the British Museum', *Ancient Civilizations from Scythia to Siberia*, vol. 10 (2004), pp. 293–338

J. E. Curtis, *Ancient Persia*, London, 2008

O. M. Dalton, *The Treasure of the Oxus*, third edition, London, 1964

B. A. Litvinsky, 'The Hellenistic temple of the Oxus in Bactria (South Tajikistan)', vol. 1: *Excavations, Architecture, Religious Life*, Moscow, 2000

B. A. Litvinsky, 'The temple of Oxus in Bactria (South Tajikistan)', vol. 2: *Bactrian Arms and Armour in the Ancient Eastern and Greek Context*, Moscow, 2001

B. A. Litvinsky, 'The temple of Oxus in Bactria (South Tajikistan)', vol. 3: *Art, Fine Art, Musical Instruments*, Moscow, 2010

B. A. Litvinsky and I. R Pichikiyan, 'The temple of the Oxus', *Journal of the Royal Asiatic Society*, 1981, pp. 133–67

I. R. Pichikiyan, *Oxos-Schatz und Oxos-Tempel* Berlin, 1992

http://www.achemenet.com

British Museum collections online
You can search for any one of over two million objects within the British Museum's collection by visiting the collection database at: britishmuseum.org/research/search_the_collection_database.aspx

Picture credits

Every effort has been made to trace the copyright holders of the images used in this book. All British Museum photographs are © The Trustees of the British Museum.

1 British Museum, BM 123927–123936, 124065–124066
2 Map by David Hoxley
3 Photo: John Curtis
4 British Museum, BM 124017
5 Map by David Hoxley
6 British Museum, BM 123906 and 123907
7 British Museum, BM 123905
8 Photo courtesy of Mrs Susan Eastmond
9 British Museum, BM 123923
10 British Museum, BM 123949
11 British Museum, BM 123939
12 British Museum, BM 123994 and 123990; drawings by Ann Searight
13 British Museum, BM 123951–3 and 123999–124001
14 British Museum, BM 123908
15 British Museum, BM 132256
16 British Museum, BM 123909
17 British Museum, BM 124098
18 British Museum, BM 123946 and 123947
19 British Museum, BM 123901
20 British Museum, BM 123903 and 123902
21 Drawing by Ann Searight
22 Drawing by Ann Searight
23 British Museum, BM 123940
24 British Museum, BM 124017 and Victoria and Albert Museum 442–1884 (on permanent loan to the British Museum).
25 Photo: John Curtis
26 British Museum, BM 124044
27 British Museum, BM 124047–8
28 British Museum, BM 124012
29 British Museum, BM 124005
30 British Museum, BM 124014
31 British Museum, BM 124015
32 British Museum, BM 124016
33 British Museum, BM 123918
34 British Museum, BM 123919
35 British Museum, BM 123917
36 British Museum, BM 123911
37 British Museum, BM 123929
38 British Museum, BM 123924
39 British Museum, 1888,1208.3; 1894,0506.2457; 1888,1208.20 and 1888,1208.66
40 British Museum, BM 124036
41 British Museum, BM 123971, 123950 and 123991; drawings by Ann Searight
42 British Museum, BM 123933
43 Photo: John Curtis